Hawthorne on Painting

This edition is dedicated
to the memory of

Charles Webster Hawthorne

1872-1930

Hawthorne on Painting

From Students' Notes Collected by
MRS. CHARLES W. HAWTHORNE

With an Introduction by EDWIN DICKINSON
and an Appreciation by HANS HOFMANN

DOVER PUBLICATIONS, INC.
NEW YORK NEW YORK

Published simultaneously in Canada by
McClelland and Stewart, Ltd.
Published in the United Kingdom by
Constable and Company Limited
10 Orange Street, London, W.C. 2.

This new Dover edition, first published in 1960,
is a republication of the first edition with
new Introductions by Joseph C. Hawthorne,
Edwin Dickinson, and Hans Hofmann.

Manufactured in the United States of America

Dover Publications, Inc.
180 Varick Street
New York 14, N.Y.

The first edition of this book was published in 1938 by the Pitman Publishing Corporation. The chief architects, so to speak, in fashioning the book out of the tremendous volume of notes sent in, were my mother, herself a painter of ability, and Miss Margery Ryerson, a talented student of my father.

I quote the pertinent sections of the Foreword to the first edition, which was signed by my mother, Miss Ryerson, and myself:

> This volume is the essence of notes taken by students of the Cape Cod School of Art through thirty-one years of the school's existence. Notes from all parts of the continent said substantially the same thing, so there can be little doubt of authenticity. It had long been Mr. Hawthorne's intention to write a book for students and young painters and this attempts to carry out his idea, keeping the feeling of the spoken words — the notes are better read aloud.

The text of my father's *Notes* has not been abridged or altered for this edition. However, the color plates which appeared in the 1938 edition have been dropped because, with the great reduction in size that was necessary (the studies were 25″ x 30″), they did not successfully represent my father's work. The introductory essays to the first edition by Royal Cortissoz and Stephen Gilman are also not reprinted.

I should like to thank two great painters and teachers for their contributions to this book: Edwin Dickinson for writing the Introduction, and Hans Hofmann for permission to reprint his "Hawthorne—the Painter," an appreciation which first appeared in the catalogue of the memorial exhibit of my father's paintings at the Provincetown Art Association in the summer of 1952. Lastly, I should like to thank Miss Margery Ryerson, whose help in all departments in preparing this edition was indispensable.

Toledo, Ohio J . H .
November, 1959

TABLE OF CONTENTS

INTRODUCTION TO DOVER EDITION
BY EDWIN DICKINSON v

HAWTHORNE — THE PAINTER AN APPRECIATION
BY HANS HOFMANN vii

CHARLES WEBSTER HAWTHORNE
BY JOSEPH HAWTHORNE xi

THE NOTES

INTRODUCTION 17

OUTDOOR MODEL 23

STILL LIFE 41

LANDSCAPE 53

INDOOR MODEL 71

WATER COLOR 83

CONCLUSION 89

INTRODUCTION TO DOVER EDITION

That plane relationships are more representable through comparative value than through implications of contour drawing was a truth which Mr. Hawthorne drilled into his pupils. I think no other teacher gave the importance to it that he did. His pupils, in their best color, being required to practice it daily, were able to understand it and, in time, to quite well perform it. It freed far more people than it bound.

In the life class, in striking through contour and mass, his counsel was always broad; he never referred to small miscalculations or omissions, and every imperfectness was at once pointed out in reference to elements as large as general character, color, or posture.

Good brushwork was quickly put in its place, and acceptableness of surface depended entirely upon color constitution.

His exceptional power as a demonstrator further increased his students realization of the gulf which separated them from a master. Though Mr. Chase, his master, was a famous and beautiful demonstrator, Mr. Hawthorne surpassed him. Seen by us during the rest, the perfectness of his first spots, coupled with the delighting surprise that they could be stated that way, made us readier than before to give his advice the almost implicit trust which paved the way to our learning the basic principles he gave us.

Our belief that we were learning important things created an atmosphere of security and hope. In retrospect, this belief is even more firmly held.

New York
November, 1959 EDWIN DICKINSON

Although the great art revolution in France was well under way fifty years ago, the spread of its rediscovered pictorial tradition was largely confined to Paris. Elsewhere, the visual arts were in a state of steady decline since the inventions of the Baroque. Had not this vacuum from time to time been filled by the cometlike appearance of several extraordinary painters, the period would have passed without leaving any vital pictorial documentation of it. These artists were great on the basis of the human quality which they had to offer and which is reflected in their work. They were true painters in spite of their lack of tradition by virtue of their sensing the miraculous qualities of the medium through which they communicated. They painted the world in which they lived and this world nourished their soul and developed their sensibility. Their time did not understand it—it did not even consider—the cultural and ethical mission demanded of the arts; if not for the creative urge inborn in Man to glorify the human spirit, it would have been without any ethical or cultural justification.

France alone held to a steady and purely painterly tradition: Géricault, Delacroix, Corot, Courbet—then Manet—and from there, in a straight line to our day. Outside of France, it was spasmodic. Best in Germany, the romantic Spitzweg, Leibl, Hans van Marées and Corinth, followed later by Ensor in Belgium, Munch in Norway and Mancini in Italy—all isolated figures. That America produced Whistler, Ryder, and more recently, Maurer and Arthur Carles is especially worthy of notice. It is with these that Hawthorne belongs. The concept of his art rooted deeply in American life; it is among these painters that his best work takes its place.

It has been said, adversely, that his technique and means of expression were borrowed from the old masters. This is shallow criticism. He is not an eclectic; it is rather that in struggle for a universal painting expression, he allied himself strongly with the only tradition that he felt.

His pictures do not have that esthetic charm so much demanded today by anemic hypersensitives. His painting is the antithesis of the prevailing misconception that admires taste and design. Taste is not a creative faculty. It is more important that Hawthorne's work is robust and provocative, that it gives evidence of an abundant, vigorous mind, of a cataclysmic temperament. As a painter, he cast aside every doctrine—so that he might surpass the limitations of calculation and construction. Art must surpass such limitations.

When, in certain works, the demands of creative dimension overreached capability, it is to details—a fish, a basket, a head in profile —that we must look for realization. But, when successful, his work carries the entire signature of the great artist. Painting rises out of the volcanic center of the artist's temperament. Compared to this, estheticism is only shadow.

When artists again became aware of the reality of spatial and formal relationship, cubism—"analytical" and "synthetic"—came into existence. But painting also asks for simultaneous consideration of the inherent quality of the colors as a creative means. It is in the realm of this reality that color must function. The painter of today is concerned with its re-evaluation as a plastic means. Both form and color have their own intrinsic laws; composition must be dominated by the dictates of both. This—only this—is painting. Mastered in this way, painting will have a mysterious and magic appeal. Mastery means the creation of a richly orchestrated "pictorial" space in which form, fusing with color, turns into a new reality—the created painting. The art of pictorial creation is indeed so complicated—it is so astronomical in its possibilities of relation and combination—that it would require an act of superhuman concentration to explain the final realization. Such an awareness is usually absent in the artist. He will never be able to explain the full process which led to his creations. But what Hawthorne as a painter aimed for and gave by intuition has become today a conscious tool of his successors.

HAWTHORNE — THE PAINTER

I am not surprised to find in the vanguard of today's movements, painters who still appreciate the privilege of having been his students. Knowing Hawthorne only from his painting—knowing from them what a great painter he is—I feel that he must have been also an inspiring and challenging teacher. However, personality, character, talent, sensitivity and endurance are inborn. They cannot be given. . . . The master and tutor is no more. Yet he has succeeded in endowing his work with what I may be permitted to call the eternal *aurore de la vie*.

1952 HANS HOFMANN

CHARLES WEBSTER HAWTHORNE

My father, Charles W. Hawthorne, was the son of a sea captain, and grew up in the seaport town of Richmond, Maine. Money was scarce during his boyhood there. He put in long hours cutting ice in the river but he seemed always to have known that he wanted to become a painter.

He went to New York in 1890 at the age of eighteen, worked days in a stained glass factory and studied at night at the Art Students League. George de Forest Brush and Frank Vincent Dumond were his early teachers.

To illustrate how precarious existence was for him in those days, he told of having been notified of an award which was to be given him at a formal reception. To his dismay he realized that he had no presentable shirt; lacking funds to buy one, he ingeniously used quick-drying china white paint to cover his cuffs and shirt front. Thus attired, he claimed his prize with aplomb.

He started to study with William Merritt Chase at his Shinnecock summer school in 1896, and became his assistant the next year. I believe that it was as students there that my mother and father met; on the same Chase school literature that showed my father listed as assistant, the name of Miss Ethel M. Campbell (the future Mrs. Hawthorne) appeared as corresponding secretary. There at Shinnecock he lived in a shack on the beach where fishermen stowed their gear; thirty years later we received a pheasant at Christmas from one of those fishermen, turned gamekeeper, who had seen an announcement of a national prize won by my father. This is one example of his ability to make friends; his acquaintance covered a tremendous range of diverse personalities.

His fascination with the sea and the people who worked and lived by it led him to Holland in 1898. That next year he went to Province-town; there he found not only an unspoiled fishing village with spectacular contrasts of sand, sea and sky, but also a clarity of atmosphere and a unique quality of light.

His ability to draw people to him brought a number of other painters, such as John Noble, Richard Miller and Max Bohm to Provincetown; his unique gifts as a teacher brought, over the years, thousands of young students to the Cape Cod School of Art, which he founded in 1899.

Probably he, more than any other one person, was responsible for the growth of Provincetown as an art center because of the success and popularity of the school. Originally attracted to its classes, many of the students have kept their close connection with the town even after becoming established painters in their own right.

As might be expected from his absorption with portraying the people of Provincetown, it was biography that interested him most in his reading. Mark Twain and Dickens were also favorites of his.

Music was one of his great loves, and this can be seen from the number of parallels he draws from music in his criticism. In New York he was a great concertgoer, and, as far back as I can remember, there was chamber music in the house. He started as a cornetist in the Richmond town band, and took up the cello later on.

In the *Notes* are many references to the part played by hard work in the development of a painter; no one ever practiced better what he preached, for he was always at work in his studio by eight o'clock, and the volume of work he produced was impressive. With all this he was a warm and enthusiastic companion because of his ability to enjoy life. He loved people, and convivial occasions were numerous in the household.

Of course his relationship with young people, especially his students, needs a special chapter. Looking back on my experiences when studying music, it seems to me that there were an amazing number of scholarships at the Cape Cod School of Art. Certainly the talent that assembled there each summer—sometimes only through extraordinary hardships—deserved them, but I know how seldom, as a rule, such need is recognized. Besides providing this large number of scholarships at his own school, he was instrumental in helping talented stu-

dents in other schools, and also did such things as get up a purse to start off a gifted young Negro painter in Europe, since he would have no opportunity on this side of the Atlantic. To me, as his son, it is most heart-warming to discover, when I meet his former students, with what esteem and affection they still hold him.

Perhaps something should be said about the actual conduct of the classes in Provincetown. The students were forced to concentrate on (to quote my father):

> "the mechanics of putting one spot of color
> next to another — the fundamental thing."

The problems were presented in an inescapably direct way. For example, a model would be posed on the beach, and the students would work with putty knives so that they could not be tempted to indicate the details of the model's face that they could not actually see under the hat in the blazing sunlight.

Also, as a means of making the student concentrate on the fundamental relationships of the main spots of color, they were urged not to finish, but to do as many studies as possible—a dozen or more—for the Saturday morning criticism, the high point of the week. In these four-hour marathons, my father used to pass judgment on as many as eight hundred to a thousand studies submitted by the hundred or more students, and cause amazement and consternation in the ranks when he would spot an occasional study that was turned on the wrong side, so that it showed one of the *previous* week's efforts.

On Friday mornings my father would paint for the class; sometimes it would be a model on the beach, sometimes a portrait or a still life. These examples, greatly prized, were drawn for at the end of the summer.

Several years after his death we had occasion to look over a good number of these studies, gathered from all corners of the continent. As we looked at them I was tremendously impressed—or better, im-

pressed all over again—for since last seeing any of them I had acquired a boat and done a lot of sailing in the harbor. This had made me most conscious of the part the direction of the wind played on the general weather, the kind of day, and the quality of the atmosphere. Each study recreated a particular day so well (as well as the model!) that I could tell from which direction the wind was blowing when each one was painted. These quick sketches had always had a special place in my affections, but this quiet demonstration, in a field I now knew well, was a revelation.

One last observation should be made about the book: it is manifestly impossible for it to represent the *total* of my father's ideas on teaching. A more eloquent testimony to the power and force of his ideas is the great number of former pupils, now painters of reputation, who hold him in the greatest esteem, no matter in what style they themselves now paint.

Toledo, Ohio JOSEPH HAWTHORNE
November, 1959

The Notes

INTRODUCTION

Anything under the sun is beautiful if you have the vision—it is the seeing of the thing that makes it so. The world is waiting for men with vision—it is not interested in mere pictures. What people subconsciously are interested in is the expression of beauty, something that helps them through the humdrum day, something that shocks them out of themselves and something that makes them believe in the beauty and the glory of human existence.

The painter will never achieve this by merely painting pictures. The only way that he can appeal to humanity is in the guise of the high priest. He must show people more—more than they already see, and he must show them with so much human sympathy and understanding that they will recognize it as if they themselves had seen the beauty and the glory. Here is where the artist comes in.

We go to art school and classes to learn to paint pictures, to learn our job. Our job is to be an artist, which is to be a poet, a preacher if you will, to be of some use in the world by adding to the sum total of beauty in it. We like to do it. There always have been and always will be people of our kind, who like to look at nature and make representations, and others who like to look at what we do.

We must teach ourselves to see the beauty of the ugly, to see the beauty of the commonplace. It is so much greater to make much out of little than to make little out of much—better to make a big thing out of a little subject than to make a little thing out of

a big one. In every town the one ugliest spot is the railroad station, and yet there is beauty there for anyone who can see it. Don't strain for a grand subject—anything is painter's fodder.

Beauty in art is the delicious notes of color one against the other. It is just as fine as music and it is just the same thing, one tone in relation to another tone. Real sentiment in art comes as it does in music from the way one tone comes against another independently of the literary quality of the subject—the way spots of color come together produces painting.

A great composer could find inspiration for a symphony in a subject as simple as the tinkle of water in a dish pan. So can we find beauty in ordinary places and subjects. The untrained eye does not see beauty in all things—it's our profession to train ourselves to see it and transmit it to the less fortunate. The layman cares for incident in a picture but the artist cares rather for the beauty of one spot of color coming against another, not a literary beauty. There are just so many tones in music and just so many colors but it's the beautiful combination that makes a masterpiece.

It is beautifully simple, painting—all we have to do is to get the color notes in their proper relation. The juxtaposition of spots of color is the only way and he who sees that the finest is the greatest man. I want you to learn to see more beautifully, just as if you were studying music and tried to get the finer harmony more and more truly all the time.

The vision of the artist is the vision to see and the ability to tell the world something that it unconsciously thinks about nature. Everyone knows what a man looks like, or a tree or a house, but it is our job to tell the world something about these things that it has not known before, some impression that we alone have received. Art is a personal commentary on nature—the more

humble, the greater the personality of the artist, the finer the work.

A painter goes out not because he wants to paint a picture, but because of the beauty and comparison of one spot of color with another, not a literary beauty but beauty because it stirs him. Painting is a matter of impulse, it is a matter of getting out to nature and having some joy in registering it. If you are not going to get a thrill, how can you give someone else one? You must feel the beauty of the thing before you start. You cannot bring reason to bear on painting—the eye looks up and gets an impression and that is what you want to register. Good painting is an excitement, an aesthetic emotion—reasonable painting destroys emotion. Painters don't reason, they *do*. The moment they reason they are lost—subconscious thought counts.

The only way to learn to paint is by painting. To really study, you must start out with large tubes of paint and large palette and not stint in any way as far as materials go. If you look into the past of the successful painter you will find square miles of canvas behind him. It is work that counts, experience in seeing color. Painting is just getting one spot of color in relation to another spot of color—after you have covered acres of canvas you will know. Don't be in a hurry to do something more—think how young you are. Suppose you spend ten years of your life just putting things together—think what an equipment you will have.

Don't try to be an artist all at once, be very much of a student. Be always searching, never settle to do something you've done before. Always be looking for the unexpected in nature—you can have no formulas for anything; search constantly. Don't learn how to do things, keep on inquiring how. You must keep up an attitude of continuous study and so develop yourself. I don't know a better definition of an artist than one who is eter-

nally curious. Every successful canvas has been painted from the point of view of a student, for a great painter is always a student.

Make notes that will help fasten your conception of beauty. The more you study in the right way, the more you progress. Each day's study makes you crazy to go back and do over and do better what you did the day before.

Do studies, not pictures. Know when you are licked—start another. Be alive, stop when your interest is lost. Put off finish as it takes a lifetime—wait until later to try to finish things—make a lot of starts. It is so hard and long before a student comes to a realization that these few large simple spots in right relations are the most important things in the study of painting. They are the fundamentals of all painting.

"You are here to represent by color, by separation of color, by exact matching of color, what you see, and thereby *learn* to *see*.

"Thank God in this time you are free—you have no public to please, no jury of artists, no one but me. You are not here to make pictures—do not worry about the drawing, make the thing as ugly as you like, but put down the colors, matching one against another.

"I don't say much about drawing because I think drawing the form and painting are better separated. Realize that you haven't yet the painting point of view—after you have got the spots of color true and in their proper relations you have something to draw with and you can then consider it.

"Remember no amount of good drawing will pull you out if your colors are not true. Get them true and you will be surprised how little else you will need."

OUTDOOR MODEL

My artist friends are surprised at my having the class paint a model out of doors, something which they consider extremely difficult. But I consider it the quickest way to get under your skin the idea of the way to paint everything—the mechanics of putting one spot of color next to another, the fundamental thing.

We paint the model out of doors because it detaches itself from other things and is easily seen, obvious—it is still life one cannot escape. The figure stands up and is seen solemnly and very beautifully against the background; it is not part of the landscape. Just four or five principal things to do—it is an ideal problem. We paint problems in order to be able to paint pictures and if we are good we keep on doing problems all our lives and the more humbly we stick to that attitude the better we paint.

A word about choosing a subject: select the thing that is obvious in its paintership—look around and select a subject that you can see painted, that will paint itself. Do the obvious before you do the superhuman thing.

Paint things you can almost reach—make a veritable still life out of everything you do. Get up close to whatever you want to paint, don't look at it through a telescope. If you are painting a ship get down beside it and look up—the thing you are painting should fill your canvas. Paint objects close up so as to get their relations; do pieces of things. Stick to things that are easily seen.

It seems sometimes as if the figure painted out of doors is easier than the landscape. Landscape differences are more elusive and delicate—a figure in sunlight is more easily seen. The house may

look like part of the landscape but the figure outdoors does not.

If the figure is against the sky, the water or the light sand, keep it as a silhouette against its background—it is surprising how violent things are up against the light. Keep the separation of figure from background out of doors.

Have the courage to set down the colors you see there—overdo in color rather than be weak. See brilliant color, then paint it a little more brilliant than you see it. Working out of doors your eye will be brought up to color—it has the effect of shaking off the shackles of your mind, showing you that you can do anything you please, making you dare. It is the most direct way of learning to see color. You will gain great delicacy and strength painting out of doors.

Problems of sunny days are more easily solved because then solid relationships are easier to see. A mass either stays with the lights or else it falls into the range of the darks, and by half squinting the eyes you can tell to which it belongs. Remember, the eye takes in all your big lights against all your big darks.

The sun is no respecter of persons—it cuts them into two great passages of light and shadow. Consider the thing as a flat silhouette, not as something round—pretend that you are copying a painting. I wish I could get you all to realize how imperative it is for your eye to travel across the form. Think of the model as already being done—as a map already painted—think of color instead of sand—think of color instead of clothes. Color first and house after, not house first and color after.

A thing beautiful indoors is entirely different outdoors. The big point is that you notice and set down decidedly on your canvas what all your light makes in relation to all your shadow—the sun does the same thing to a face as to a pole. Get the shock as shadow comes against light.

Make your canvas drip with sunlight. You cannot reproduce nature out of doors for it is impossible to do what you see; you have to approximate by a convention, to invent one. Exaggerate to give the impression inside that you feel outside. Key your work higher than nature really seems to be, and when you take it indoors and hang it upon the wall, it will come nearer to the truth or to the way you want it to appear indoors. You may have two pictures, one by an impressionist and one by George Innes; hang them on either side of a window and one will be just as brilliant as the other, for you can't compete with light. You have only paint to deal with—that is to say, you have to take liberties sometimes. Paint is limited in its range as nature is not, therefore keep the lights (the sky, the water, and the sand, the top of the parasol or anything in sunlight) as near the same value as possible. Keep the mass that is in shadow, always in shadow, and make differences by gradations of color.

Everything in painting is a matter of silhouettes. Hold light against shadow, not light against light.

The model out of doors ceases to be the same human being that she is inside—in a head on the beach the features show as reflections, are not drawn as in an indoor head. It is amusing how little one needs features for likeness—think of color notes; spots, not planes, when doing the face out of doors.

Draw as little as is compatible with your conscience—put down spots of color. Seeing things as silhouettes *is* drawing—the outline of your subject against the background, the outline and size of each spot of color against every other spot of color it touches, is the only kind of drawing you need bother about. If you do that faithfully you will be surprised at the result. Think in color, think in color volume. The majority of painters don't realize what it is all about—they believe in reproducing nature in-

stead of expressing themselves in beautiful spots of color. Let color make form—do not make form and color it. Forget about drawing; let your drawing in the painting be unconscious so you won't get into the habit of making things brown and making them dark to make them go round.

I don't care about the roundness of the head. That takes care of itself if your color is right as it comes against the background. I don't agree with those who insist you must think of the air between the head and your background. You are painting on a flat canvas—it's the relation of one color as it comes against another that you must see correctly. If it's flesh make it live.

Do not put in the features. The right spots of color will tell more about the appearance, the likeness of a person, than features or good drawing. Make it so that I could recognize the subject from the color alone, for color also is a likeness. Remember no amount of good drawing will pull you out if your colors are not true. The spot of color that a model makes against the landscape has much more to do with his character than you imagine. Do that and you have something to work with. Our tool of trade is our ability to see the big spots.

Starting with a note of truth in a picture is the important thing —the first color you put down influences you right straight through. Do not put things down approximately—you will take a wrong thing and unconsciously key everything to it, making all false.

Don't be afraid of flesh, think of it as a note of color. See the greener note in the flesh, the solemnity that flesh has out of doors. Get it out of your mind that you are doing flesh out of doors, you're doing nature out of doors.

Go out like a savage, as if paint has just been invented. Put it on with a putty knife or even fingers and you get something

fresh—water is wet, sky has air, you can walk into the canvas. If you go out with brushes you do it subconsciously in the way imbedded by old custom in the mind of the human race.

What I want you to do is to make many palette knife sketches, small, simple, of three tones only if possible, showing the time of day and the weather conditions.

Don't spend all morning on a beach study; if it's a bad one you can do all you know in twenty minutes. Start a new one. I don't want you to work one minute after you don't know what you're doing—better to start again and carry it further; don't work after you've stopped seeing logically.

Don't paint thinly as a student—later you will, but there will be something lacking unless you first learn to paint with more pigment. Paint with freedom, it gives you more mastery of the nature of paint. Make a lot of starts; wait till later to try to finish things. Do three or four of these studies every day, and leave the picture making to those who call themselves artists. First become the painter and the artist will take care of itself. Paint with a broad firm brush, loaded with color, noting values frankly. The feeling for color will come and grow. Swing a bigger brush; you don't know what fun you are missing.

Let's not be so precious with ourselves. You are at an age when you are supposed to make mistakes. If you are healthy you will make them. Have enthusiasms—it helps your work if you have a good time. Don't be afraid of being young. Now that you're young and fresh have the strength to try and use it. We must train ourselves to keep and preserve our fresh and youthful vision along with all the experience of maturity. If we do we'll be great artists—if we don't we'll be academicians. We are training to make ourselves big people—learn something today to put in practice to-morrow, and then you will arrive at old age still fresh. I believe

in so training yourself that there will be no end, that by a long life of serious effort we may do something more beautiful than nature.

Criticisms of individual canvases. Small boy in white cap, and bathing suit, posed on the beach with harbor in background.

I want to see that background more brilliant and that head a silhouette against it— the figure does not make the hole in the canvas that it did in nature. That should stand up there so much more decided—it is surprising how violent things are up against the light. I would like to see it blaze a little more against the background—that startling brilliancy of heads against a background outdoors. Yours is too much sand and water, not enough a blaze of light. If you had kept your eye on the figure you would have seen the sand and sky much lighter.

§ § §

Tanned Portuguese child on the wharf with the sky as background.

Just try a section of flesh against a section of background. I want to see a little more quality in the note of the flesh—there ought to be more of an ugly kind of beauty in all these darks in the face. It is really surprising how *dark* things come out of doors.

§ § §

Model posed on beach.

Don't be afraid of mixing your colors. Some of the most beautiful colors in a canvas are nothing but mud when taken away from their combination. To see a beautiful flesh tone against brilliant sand and to be able to recognize that a piece of mud color from the palette put against a brilliant yellow on the canvas will give

the illusion of flesh on the beach—that takes an understanding which comes as a result of study.

§ § §

Child in a large hat • That's an understatement of the thing— *in brilliant sunlight—* nature's much more frank than you have *face all in shadow.* been. Don't be too reasonable, get a little bit excited, give a little more truth of impression—say, "Oh how ugly that is, I want to paint it." Suppose music were all a little thin piping without anything hoary and grisly that reached down to the emotions. This canvas does not show the joy, the glory of creation, the thrill of seeing the thing for the first time. Show a little more pleasure in putting down surprising things that you want to tell the world about.

§ § §

Each time, I feel like saying—forget drawing!—only that adds to my already bad reputation. There's a big kind of drawing that has its relation to the big silhouettes, instead of to round common eyes, noses, and things as they are. I can see you struggling with *making* a thing: let it make itself. You'll be surprised to see how little drawing you need if you *make* the spot of color and approximate the shape—then the drawing is more real and you won't need the kind you learn indoors.

Try painting a simple still life on the beach, if the model outdoors is too difficult for you.

§ § §

You don't need to cover your board with paint clear to the edges. The tones that come against each other are the important things. My imagination can finish the thing far better than you

29

can paint it. Wait till later to try to finish things—make a lot of starts.

§ § §

Pictures are more legible than the printed page, more credible than oratory—there's one thing you can't fool me on—I can read oil painting. I can tell you more what you were thinking about than you yourself knew at the time. Keep your mind clean—what you put on your canvas is an index to your thoughts and I can tell your character by the way you paint. Have an inquiring mind, don't get into a way of doing things. If you do, something stops; you don't grow, you get a fixed habit of mind.

§ § §

Don't paint so much from memory, from what you've seen someone else do. Just put down what you see.

§ § §

Girl in light dress, face shaded by hat; in brilliant sunlight, posed against the light sand.

This little head on the beach comes near being very well—not a feature in it but so true that the same thing happens when you look at a man talking to you, you only get the spot.

§ § §

I often see a screen full of studies with not a feature indicated, but I know those children! I don't need eyes and noses to tell me who they are if you've done your job well with the color tones as they come against one another.

§ § §

That wharf there back of the head! You didn't try to make it a wharf, you didn't worry about the distance between you and it, nor the atmosphere between—you painted the color as you saw it against the head; and it's right. It goes back into the distance because the color is right.

§ § §

Girl with light hair dressed in white; posed on beach. Don't have the yellow in the sand the same yellow as in the hair with white added to it. Nothing cheapens a canvas so much as the same color running through everything. Harmony and vitality come from the use of different colors, not using one color throughout in its variations.

When you think sand is hot look at it in comparison to a hot note of flesh. A little blue on the sand would make it something away from the head.

§ § §

Tide going out. When the background is changing, such as wet sand and water, watch very carefully the big note of the head in shadow.

When painting the color of the water in back of a figure, don't try to paint the color of the entire Atlantic ocean. Paint only that part of the water which is directly in back of your figure.

§ § §

Model on beach, sun behind back. Make background and figures represent the same kind of day—think of your work as the portrait of a day rather than of a model. The sunny effect could have been made more true, could have

been made to blaze up by some stronger contrasts—keep the figure and the big blond background more greatly separated.

§ § §

Model posed on dunes with distant trees as background. When you go outdoors, different conditions obtain—make the color note of the face, and the nose will take care of itself. In this study you shut out everything but your preconceived indoor knowledge. Remember that your eyes are just seeing machines. Telling the truth is looking out and giving a snap judgment without any preconceived notions; in other words, telling exactly what you feel about it. Look only for the spots and establish them and they will be trees, background, flesh; and when you come to make features, you'll have the tools to work with, the tools being your ability to see spots of color. Let's see you shout some tones together and have some fun.

Always remember that anything you can do outside to make it more like the thing when taken indoors is the thing to be desired—you study more when you exaggerate more.

§ § §

You must get the vitality of out of doors—the thing to be kept in mind is the beauty of the spot of color that the thing makes. Get a dance of light, the gaiety of sunlight—let me feel the sun.

§ § §

My! but this is outdoors—it just drips with sunlight. You like things of this kind the way you like a straightforward person—it talks to you, so frank, so serious. This attitude is beautiful.

§ § §

We must all teach ourselves to be fine, to be poets. Spend a lifetime in hard work with a humble mind. In his attempt to develop the beauty he sees, the artist develops himself.

§ § §

The layman does not know how the picture ought to be painted—you have got to show him. When you can do this you will have an audience.

§ § §

Try coping with different sized canvases. There is a certain influence that the big area of canvas gives you—it makes you see things larger. There is one thing of which you may be sure, being able to paint large canvases does you no harm when you come to paint a small one. Take out large canvases—when I say a little one I mean a 16″ x 20″.

§ § §

Color may be subtle on a gray day, but the spots insist as much as on a sunny day.

§ § §

Simply graying won't do—in nature it is more than that. If you have done your job well, anyone can tell if it is morning or afternoon light by the color you use.

§ § §

Get excited about it. I don't mean getting out and tearing your hair—but paint the thing that makes you all a-tremble with its beauty.

§ § §

Don't model little blue hats in an outdoor portrait—you saw this too much as a hat and not enough as a spot of color. Look at some positive dark to get the value of water behind the head —hold up the black handle of your palette knife to compare it with the darks in the subject.

§ § §

Hats always go in circles.

Remember that in doing a head with a hat on, there is one economical dark that means drawing as though nature were making the most of one or two accents; she is economical in accents, she doesn't spatter them all over.

§ § §

Of course we don't think all the time—but why work when we are not thinking? Don't confuse this kind of thinking with the sort of reasoning I have said a painter should not have.

§ § §

This canvas would not give anyone an emotion—get more punch in your things. You lack that putting down a juicy note. You are not elemental enough. I don't care what it looks like and don't *you*—get something that isn't restrained. Get something that isn't translated into a pattern of the thing. Make the thing sing of the joy of sunlight, of the beauty of sunlight. You're vital enough, you're young enough—you can do it. Yours is done more with a sense of design than as something giving a thrill of excitement at the coming together of spots of color.

§ § §

Portuguese boy in white shirt and sailor hat, sitting on barrel. Be more interested in the workmanlike viewpoint, it is so much more healthy. Be interested in the shadow under a white hat. There are no two white hats alike and each day is different—get into the attitude where you are thrilled by two shadows coming together.

That point of view is so beautiful, so sane that it is worth while in itself. By working with the abstract point of view, that of the workman, one spot against another, we achieve the concrete. This is the only logical way to get at it. Seems simple. It is simple, but one in ten thousand ever achieves it.

§ § §

Be careful in drawing the shapes of your shadows. Don't cut them up too much nor put too much in. Hold them a little more together out of doors.

§ § §

Model on beach, cut sharply in light and shadow by the sun. The edge of a shadow is so eloquent— where it touches the light it looks stronger and you can get more luminosity beyond the edge. Get brilliance and not so much white in them.

Your outdoor things are just a little heavy. I think the reason is that you haven't separated your light passages from the dark quite well enough—all of that dark note should be a little more of an accent against it. Put on one or two spots of pure color as pace setters.

The eye takes in all your darks and all your lights—get the big general impression and the lights will pale off into each other.

§ § §

35

You know too much—an illustrator, aren't you? I thought so. You think you know a great deal about the structure of the face —the bones underneath. Forget all that! Don't try to show me how much you know. Be humble about it. Paint the color tones as they come against each other, and make them sing, vibrate. Don't ask me to look at these self-satisfied, pretty things.

Compared to a simple study by another student. That fellow there knows far less about this business than you, yet I'd far rather see his sort of thing, crude though it is. Oh, how refreshing it is to come upon a bit of truth in an exhibition of smug sophisticated things! That crude sketch would stop you short in any show. It's real, it's flesh in sunlight—there's truth in it.

That as line composition would probably smash all the canons; everything in it is bad; but how delightful it is in painting! I've often asked people who are in favor of teaching composition, if they can remember a piece of beautiful painting which is bad composition, and they never can. It comes to this, that if you plotted out a beautiful composition and a master and a dub painted it, the master's would be fine and the dub's very hard to look at. All I can say is, cultivate yourself and your tastes. Grow!

§ § §

Boy on beach—in white shirt partly in shadow. Make it so one is not conscious of the color. Make the untrained eye see a head in shadow, not that the hair is purple and the face yellow. Don't brag too much about seeing that purple—you may have purple shadows but make the purple so it will fool me. A white shirt in shadow should be a white shirt in shadow, not a

purple color. Get the sullen beauty things have in the outdoor light.

§ § §

If you have to lie, make your lie convincing. I don't mind your lying to me if you can make me believe it. Make me force myself to admit that you are good—force me to hold out as far as I can —just as if I reluctantly had to admit it.

§ § §

This model in red instead of the usual white or light colors.

A positive color as a gown, etc., is very difficult to paint out of doors. White is much better as a subject. Get quality, not white paint.

§ § §

Small boy in brown shirt and black cap.

There is nothing harder than black in sunlight, and beware of brown out of doors.

§ § §

Model in red sweater.

Always remember that the thing which to you looks difficult may be very easy. I can assure you that warm tones and lights and shades paint more easily than subtle things.

§ § §

Man alive, are you going to let that weak girl get ahead of you. Put some punch in it, get into it heart and soul. That's a meagre output for a boy of your inches. Get out and work, time is slipping away. Remember, the successful man has a hard time back of him—it's fun to be successful, it's worth the price. No

one is so important or ornamental that he has the right merely to exist; we have to do our share. Acres and acres of canvas are what it takes to make a painter. Be a bit brutal and fear no one, least of all your subject.

§ § §

Girl on beach in dress almost same color as shadows on her flesh.

Notice colors that are near to each other and make them different. Make, for instance, purple with various combinations of color.

§ § §

Girl in pale yellow dress against sand.

Be a little more insistent in color out of doors—make an overstatement rather than an understatement. Things can be pale even when made in pure color.

Things close together should be held so that exact differences between them are gotten. The more closely two things come together in color the more care you have to exercise in separating them. The big things like shadow you must especially watch over. Look at objects through a hole in a piece of paper in order to compare the different colors coming together.

§ § §

Girl under light parasol.

Oil painting has its limitations. We can't paint nature; it is all a big prevarication, but we have to tell a convincing lie. You can make only a sign language for sunlight.

Don't try to reproduce nature but make the illusion that the object gives out of doors.

§ § §

Your study would have been much more sunny if all the lights had been held nearer together, all in a blaze of light.

Your colors are muddy; brighten up and have more fun. You are getting too serious about it. I want you to go out and bring me in a square of color—I might not know much about the subject, but it must sing with out of doors. No matter how childish it is, if it's right, it's like a fresh breeze, something you don't experience every day, something enchanted. When you make a piece of canvas live and it makes you feel out of doors, then you have something.

Perhaps we analyze too much. Try putting down your first impressions more. Do what you see, not what you know. Put down each spot of color truly and sincerely—remember that it is the large spot of color that tells the story. Make the big tone and make it true—don't approximate and then do something to it. Conduct your canvas so that when looking it over you will have the several big notes larger. It is a mental process—noting tones and placing them correctly.

§ § §

Funny thing about painting, you don't know what makes it right but you know when it's wrong.

STILL LIFE

This winter do some still life, and I don't mean pretty things like iridescent glass. Do still life because you cannot tell a story about it—paint something that isn't anything until it is painted well. Get stuff that is supposed to be ugly, like a pie plate or an old tin basin against a background that will bring out the beauty of the thing you see. Then try to do it, trying to work for quality of color.

The painting of still life gives one the widest range for study— a bottle is as serious a subject for portraiture as a person. In arranging, place things so they have color and so that you can see it well. If you cannot decide on color and values in the beginning, move your still life around until you get things simple so that you can see big relations.

Select one light thing against a dark thing—a kitchen utensil and a lemon cut in half—try for spots coming together.

An old bit of white china—the way one paints white or black is the test of being able to paint at all. Old restaurant ware used a long time acquires a wonderful beauty of color. Go into a cheap restaurant and if you see a beautiful piece of white crockery, get it. Try to make it look clumsy, it will keep you from being satisfied with well turned edges. Clumsiness indicates a struggle to put things down right, an honest effort to grasp the truth.

The study of old crockery is very exacting, very wonderful.

You don't hear me say much about drawing. It is because I think drawing the form, and painting, are better separated. The

first thing is to learn to see color. You will draw better a year from now if you disregard for the time being the thing you call drawing. Realize that you haven't yet the painting point of view —after you have got the spots of true color in their proper relations, you have something to draw with and you can then consider it. Don't consciously try not to draw but do the other thing so well that it will draw itself.

Don't look up at nature and consider an inch at a time. See what one big spot is in relation to the other big spots.

Search always for more beautiful notes of color, don't search to put more things in.

Study larger spots of color coming together—don't break objects up into many colors.

Establish big general things. You can't make all the differences you see.

Insist all the time on one spot being right relatively to another. I'm trying to say that when you think straight that thought alone is worth while and when you put down one or two notes that are right that's all that is necessary. You'd be surprised at how little work it takes to make a picture.

Have some fun with color. Enter the dishpan and palette knife brigade. It would not detract from your work, from what you like—that is, line and composition—if you should add color charm. Take a dishpan, some bricks and tell the beauty of them. It would take the study out of the commonplace and make it a work of art. Do still life and see the beauty you can get in it. There is something elevating in the painting of a side of beef so it can hang beside the Madonnas in the Louvre and hold its own through the centuries.

Use the knife not to draw with but to make color differences and bigness. Its use gives greater freedom and keeps you from

breaking up big tones. Concentrate, hold yourself to do large spots. The big painter is one who looks and does, the little painter is always tickling with a camel's hair brush. My plea is for something big and fine and honest.

If you do little sketches do them with a palette knife or a wide brush. There is no sense in doing small canvases unless you do them in a big way. Get out with a palette knife and have some fun with it. Paint with a knife that has no point.

Use a brush if you want to. The palette knife gives you the feeling of working in a new medium, gets you over the old established habits that need breaking up; that's its only virtue. But look out! There is a danger of becoming enamored of the palette knife technique.

Keep your study in silhouettes as if you had a plate glass before you and you were noting down spots of color on it, putting down on the glass what you saw through it. We are dealing with silhouettes just as in a map, representing the round by working on a flat surface.

You do not have to think of planes if you think of color; note a spot of color, and then the plane will take care of itself.

§ § §

Let the eye go from one spot to another without the aid of outlines. Jump from the center of one spot of color to the center of the next. Keep your eye away from the edge a little bit more —don't insist that the eye shall stop at the edges. Mechanically lose them by rubbing the palette knife through them. Destroy the outlines of this cup in your canvas and you wouldn't be able to find it, and that is not true in nature. Don't paint up to a line, work from a center; don't fill in an outline but make the

inside form the outline. Look to the center of colors more so you won't concentrate on edges but on the interior. There is no such thing as an edge in nature so don't worry about wire edges. If your values are right you won't be offended by too much edge; it's when the values are bad that you criticize a canvas as too edgy, and remember that if your colors are right your values are right.

§ § §

Let the objects in your study be simple in form—few in number—and let the arrangement of them be simple; no multi-colored objects, no little objects—no decorations, no filagree on vases. As background, take drapery with no design—an arrangement on a white table-cloth is often good. Sometime try turning up a box so that it casts a shadow over part of your study.

§ § §

Don't make things seem to go around so many times that it makes one's head swim to look at them—you have brushed around to make the bowl go around but you should have gotten it with spots of color. No matter what you think, where the study is commonplace, you took it out of God's hands and made it go round instead of trusting to nature and to luck—trusting to science rather. Just do what you see and stop there.

§ § §

A mannerism in a man who is a master is charming, but in a student, it is hellish!

§ § §

That canvas looks a little more like it—looks as if you had a few ideas; I mean painting ideas. A philosopher would probably be a low grade moron if he tried to paint.

§ § §

44

This is just a trifle self-consciously a jug. It is too much a pitcher and not enough porcelain.

Try to get a little more weight in your darks. The opening of the jug was much darker than anything on the outside. Appliqué the jug on the canvas, don't cut it out against it.

Note the different qualities of reflected lights. High lights have parts of their edges sharp, others accidental looking—the smudge of the thumb effect.

§ § §

Old faded material often good.

Remember that the background becomes background only in relation to the thing you're doing in the light. I have to look hard to see your canvas as a whole.

If you had varied your background, it would have been easier to look at.

Make for a little more vitality in them.

Don't try to flatten out one tone to cover the whole surface. Decide on one spot and then don't stop—look again and then don't go back to the palette and take the same color. Do it entirely again. I want to help you out of making a plaster background.

§ § §

Red apple, white plate—greenish gray background.

Try to decide the color of your big spots and keep them apart—try everything in your power to keep them apart.

§ § §

45

I am always talking of how the right note of color takes the place of drawing—not to show its unimportance, but the importance of the right note. The right combination of color will supply the drawing much more than the opposite—this subject might be drawn by your favorite draftsman and never give the sense of reality that you have given.

§ § §

Tapestry or chintz. Always remember when you have a print to paint that a flat thing has a different surface than a round—so a print would look flat no matter how strong it is in relation to a weaker object in front.

§ § §

Still life of a brown earthenware jug. Take the ugliest object or subject and make it beautiful. Do not look for pictures in nature, get a problem.

§ § §

A row of old bottles. You cannot make me believe that the high-light was just there. It was somewhere in the neighborhood but not just where you put it. This is an example of that lack of looking and seeing which is the most damnable thing in painting.

§ § §

You don't know how awful this study is. Of course, I know modesty makes us say—"I know it's awful," but it's a human impossibility to know *how* awful the children of your brain are. You hear criticism, but like death, you think of it always for someone else.

§ § §

Make still life stay on the table by careful indication of shadow. There is a distinct difference between your brown jug and the table. Watch, by spots of color, and make them more subtle in relation to the background. Don't brush into the background —instead, put the right tone on first.

§ § §

Oranges in a white bowl.
You're beginning to make things as objects instead of doing the beauty of one spot of color against the other. You do not have to do what we call modeling if your color spots are right.

§ § §

The hardest thing in painting is not to paint what we have seen. In doing this, you were influenced by the way other men have dealt with the same problem you were struggling with. This is a description of the apple rather than a visual conception of it. You have done it flatfootedly from what you thought the thing ought to be, not at all from the painter's point of view. Don't think of things as objects, think of them as spots of color coming one against another.

§ § §

Tin dishpan without enamel.
As a test to anyone who thinks he can paint pretty well, let him take a dispan, fill it half full of water and put a slice of lemon in it or something to give surface, and try to paint it to get some quality in it.

§ § §

There is nothing in the world so helpful to a young painter as a study of white, if he will but be honest.

47

Old fashioned white china wash basin. White to be beautiful must have a contrast. An old white plate against sympathetic background is exquisitely beautiful, but be very careful when white appears to go warm—you lose its power. It will help you if you keep a part of it pure white.

Put variety in white.

Watch out for grays. Paint them, don't depend on the color of the canvas.

§ § §

Get a dishpan in a quiet light, and put some dull red near it. Then go at it with a palette knife. It helps you to see the subject as spots of color—it is a clumsy tool, and a new way of working, making you too clumsy to put in details, forcing you to concentrate on the big spots. There is something noble about being able to paint a dishpan that anyone would be glad to hang in a drawing room.

§ § §

Fish study. It looks as though you thought of fish first and color afterwards instead of color first and fish afterwards. Before you learn how to draw you have to do something else—you have to get the big masses. It's nice in color but it's too much of a ghost of a fish. It wouldn't flop!

§ § §

Decorated vase, small statuette against figured background. In yours, I feel the picture making too much—it has the misfortune to be unique in form, therefore you make a potboiler out of it. Do the same subject again and give me an impression, how one spot of color came against another. You're not here to

48

paint pictures but to develop yourself—you are just getting tools to work with later on. Here you have no public to please—no fond relatives. You only have the canvas to paint over and use again next week. My plea is for the mechanician—you have to know your job—the painter's attitude is technical always. Masterpieces are seen clear-eyed, calm.

§ § §

Still life of a wooden cat and dog.

Painted like a true artist—might have been a madonna and child.

That frying pan hanging against the wall has a solemn beauty.

This stove is painted with a soul—there is as much beauty and religion in the painting of this black iron stove as in any of your so-called religious paintings. That is sacred—you have put your heart in it. One of the greatest things in the world is to train ourselves to see beauty in the commonplace. Out of a consideration of ugly tones grows a real beauty—a freight car or a wash line of clothes may be as handsome as a sunset. Discover beauty where others have not found it.

§ § §

Black is almost a test of one's ability to paint. There isn't any more beautiful color than black, but when you take to using it whenever you want a dark it is time to take it off your palette. The subtle color of black and white is more beautiful than that of pinks and whites. Care must be taken in adjusting its relationship. It is easier than that with pinks and lavenders.

§ § §

*Delicate bowl with
light green
background.*
You have gone *pretty* again this week. Nice as these still lives are they are made of glass. Your apples would break into a thousand pieces, they are so precious and lacking in vitality. So much energy is taken in admiring them that you haven't any left to paint with.

Try to do ugly things so that *you* make them beautiful—these are too pretty for words, one expects to see fairy dancers. I'd like to glaze them with mud to get a little of every day dirt in them. Get away from the preciousness—that's cheap ideal. Get a little human beauty in them. The more delicate the thing is in nature the more one must look for the solemn note. Color in nature is never pretty, it's beautiful.

§ § §

For studies of flowers make careful selection of a background, and make the bouquet an entity in relation to it. Remember the background is vital, as important as the subject.

These flowers are done too much with a sense of design instead of with the thrill of spots of color coming together.

Keep your silhouette of flowers clean—they are more exacting than anything else.

§ § §

Your work is too hard and overdone. It is from anxiety to do it. Have more fun with your work, you are liable to get stale the other way. Loosen it up—not so tight. I don't mean that exactly, for a beautiful painting can be tight as well as loose. There is nothing in loose painting, but if your painting is right,

that is, your spots of color, you will not need nor notice the lines or little things and it will look tight.

Get away from strain in still lives. Don't let them be a mental strain.

This is too pretty. You were carried away by the prettiness of the subject. Next time select an old coal scuttle on the beach. Find solemn beauty in it, see real beauty. I don't care how pretty things are in themselves, when you get them outdoors in the sunlight the whole thing has a solemn note; it has a dignity about it. Try to get the bigness of nature.

A broom and a pail, large, in the sun, are a good study; also an old dishpan or wash basin. If you don't get it, you won't have anything.

§ § §

The successful painter is continually painting still life.

LANDSCAPE

The weight and value of a work of art depends wholly on its big simplicity—we begin and end with the careful study of the great spots in relation one to another. Do the simple thing and do it well. Try to see large simple spots—do the obvious first. When you go out to paint and things mean only spots of color to you, you have your painter's eye with you. Make a house a note of color, make the blinds and windows a note of color, make the trees a note, the grass a note, the shadows also and make the sky keep away from it.

See if you can't simply put down spots of color and let the results take care of themselves. You have got to be able to see these spots come together without outline and let the outline come after. Look to the center of color spots and don't be so particular about where the edges come together.

Don't depend upon outline to make dark against light—it's all a matter of silhouettes. To paint a tree look at the sky in comparison—see the tree in relation to the sky, the house, the road.

Don't see so many little things—refuse to see details—you don't have to draw the whole town if you paint. Better put it down so that it sits in air than to make a better drawing without the vitality—have a large general vision so you can discriminate. However, one has to be very careful what one says about drawing, for it isn't that I don't want you to bother with drawing but that I don't want you to do it at the expense of the other thing.

If you will only put a spot of color in the right relation to other spots, you will see how little drawing it takes to make form. Let color make form, do not make form and color it. Work with your color as if you were creating mass—like a sculptor with his clay. Interest yourself in the relation of one color to another—in this way your color rather than drawing creates form. The values rather than the drawing make a boat stay behind the piles of a wharf.

How many people pass this place (a house and simple surroundings close to the street) every day and never see it! Once it is seen, painted, and put into a frame everyone will come to look at it. It's the artist's business, the painter's job to point out to the public the beauties of nature.

Try to see them before you start to paint. Don't try to see a picture—go around and look at the subject until you see something, say in trees or houses, coming together, that inspires you. We do well the things we see already painted in our mind's eye —don't do it until you see it or you are defeated before you begin.

Generalize spots of color in a landscape—against the sky make one spot instead of two. A house through trees is a dark note. Things should stay in a general spot. Let spots be brilliant inside the shadow—keep down reflected lights, so they won't stick out of it.

Landscapes are the same problem as a figure set up against the sea. Make the town a silhouette against the trees behind it and the trees another against the sky. Out of doors the light takes the modeling out of things.

Look at the view with your head sideways to get better relations, so that you get a sensation of the color spots rather than a perception of objects as objects.

Consider the big spot of the earth and the big spot of the sky —start your canvas by putting down a small spot of color for each. Think of the sky more as a curtain—hold up a piece of white against it to help you judge its value.

The effect of nature at the moment sets the key. Put the subject down in shadow first, then in sunlight.

Separate into big passages of light and shade. Get the big simplicity of foreground in relation to the mass of sky. In doing the sky concentrate on something in the study to get its relation to the landscape. Always have something within about ten feet with which to compare the color values of your distant objects.

Avoid distant views, paint objects close up. If the foreground is well done the distance will take care of itself. By having the big lines of the composition going out of the canvas, your imagination can wander beyond the edge. It will make it seem part of a large composition. Have as much fun as you can and don't feel that the edge of your canvas confines you—let your vision go right on.

The difference in the lights does not need to be shown, but the difference of shade against light does. Look from your big light to your big shadow and see how closely everything holds to one or the other.

§ § §

Picturesque grouping of old houses. That canvas is a little weak and it comes from a concession to picture making. Work for simplicity more. Keep the lights together, the darks together. Your gorgeous color will not count for much and will result in noisiness unless you make the big generalizations. Separate lights and shadows enough to make them solid. Don't get too many things in the light—avoid too

many branches, too many windows, too many spots. Only the owner of a house counts the windows.

§ § §

White house and yellow car, both in sunlight. You have to get up in the scale out of doors because we are dealing in approximation. Seize upon the spots of shadow and approximate them. The gamut of nature's colors is so great that in our medium we can't approach it, so drop all your dark values to give the white lights a chance. Make the big yellow note of your car a little lower in key, so that the highlights will stand out from it. You pitch your car so high in key that you have nothing left to study with, and when you come to your whites you're juggling.

A master has the knowledge to do something like this but you cannot do it. You must learn more about form by depicting the thing even a little lower than it comes in nature, for we have no paint, no materials which can pitch the value to the height to which it belongs. We can only represent variations by difference in tones. Pitch your painting lower in key. Make it more vital. Allow more range to work inside.

§ § §

Picturesque willows overhanging white house. These things are too beautiful for use. The subject may be very beautiful, but it will only be beautiful with a veneer of the thing I was talking about—that is, it will be purely literary painting. The reason is that you have thought about it in that way—that it was a landscape. You painted it because it was beautiful, but you did not have a sense of how beautiful those shadows were,

coming against the sky. True, you have made the house of the correct and conventional shape, but it couldn't possibly have meant anything to you; you did not specially settle yourself to paint that scene with the conviction that it was beautiful, that it was a beautiful subject. That was yellow sunlight, these windows would be purple—true, these windows of yours are the accepted shape, but see how in Sargent's water colors you have a conviction of shadow before you notice his purple. I want you to see things from the realization that your drawing does not need to be a house. The view that you must take is that this is a piece of God's outdoors, that this is shadow and this is light. You ought to tremble before it, and not sit down like a magician and try to make windows.

§ § §

Trees. Notice the color of the foliage as it comes against the sky, the pattern it makes. Make it as interesting as nature does.

Trees should be more silhouetted against the sky. In doing them put in the openings where the sky shows through in proper shapes and the dark and light in mass.

Things out of doors are very much of a silhouette—silhouettes and patterns are always vital whatever the conditions of light so long as we can see at all.

On a gray day the light has a way of being a rim around things.

You see the masses of light and dark and sometimes forget the tree as a whole spot in its relation to other things—after all, we must see the large spot of the tree against the sky.

You paint leaves too much and you have too many little lights and shadows. It makes it cheap to have the little darks and lights so marked; trees should silhouette more. Gather together the big lights and shadows, don't break them up.

You should do planes against light, not leaves and grass—I would like you to have seen that not so anatomically as you have. There isn't any reason for not doing every leaf on a tree if we can, but we can't, so do only the large notes. Don't do the tree, do the spots of color that the tree makes—tell the truth about the relation of one color against another, and it will become a tree or a house if the right color is there, not because of the form.

Anchor trees to the ground with their shadows. Ask yourself what kind of a *hole* in the landscape does the tree or house make?

Now that's a beautiful tree against the shadow. Your ability in painting is the way you see things come together—our métier is not paint and brushes, it's our ability to see.

Better have it true in aerial perspective than in linear drawing —despite the puffiness of your tree one would not hesitate to walk under it.

These should not be houses to you and not trees—to the painter they are a pattern, an arabesque. See things as spots against the sky, watch for sensitive silhouettes.

§ § §

Things pattern on a gray day a little differently than in sunlight, but they pattern none the less.

§ § §

There is not so much difference in color—it is the relation of the lights to the darks; they may be very high in key, but all values are close together. The whole note is a silhouette on a gray day more than on a sunny day.

§ § §

A Cape Cod fog. That is a gray day of course; it is no small thing in painting to make people see what kind of day it is. I have seen things so sensitive that you could tell whether it was morning or afternoon. That is painting—to tell people what the thing looks like. I once painted a canvas and someone said, "That looks like Sunday morning!" I don't know why, but it did, and it *was* painted Sunday morning.

§ § §

Here you had not settled in your mind what interested you most—you did the scene instead of working at a problem. There isn't room in your consciousness for more than one sentiment about a thing. Tell that one.

Don't be carried away by a flower garden. If you are a painter you will see beauty in pieces of old white china, beauty in the way the light breaks up the white into all the colors of your flower garden—only a more somber and more serious beauty.

§ § §

Yours is too much of a white house and not enough spots of color—you have painted the house from what you know and not from what you saw; what I want is that you paint this spot of color (the sky) coming against this spot of color (the building) in their right relation—then your work will have much more vitality.

When you get outdoors doing houses and boats, you draw them to death and the spots aren't right—I want to see it in afternoon sun more. Let your idea be not that you are doing a portrait of that place but of that time of day.

Look at nature and try to visualize—see it on your canvas before you begin. Approach the study of the fishing vessel from my point of view; not painted because it was a fishing vessel against the wharf, but painted because of one note against another.

§ § §

Do the essential thing and don't consider the rest—a sketch has the essential things and stops there; for that reason it is good, not because it is a sketch. A study carried further, still featuring the essentials, is more important.

§ § §

Roof tops. The whole thing hasn't the surprise of truth. Don't reason—by reason I mean don't say that I must have a cool light over this, for it gets a light from the sky. It's a sad commentary that nothing is so startling as truth to human beings—in a canvas too. Be a vital painter or they will take you to be academic.

§ § §

Harbor in sun. The lights are much more apart from the shadows—the only way you can get an illusion of nature is by noting the differences between one thing and another. The sky should be brighter than anything else in the picture except surfaces that reflect sunlight directly—the

sand breaks up the sunlight and gives warm colors, the reflections of the light from the sky are cool colors.

§ § §

Don't look too closely as to what's in a sky—keep skies in the aggregate, as a piece. Don't feel you must get vibration in a sky —see what kind of a blue it is and keep it clean.

Paint skies more heavily so canvas won't show through.

Remember the sky is above the earth; look at the section below and see if they correspond.

In your study why did you reduce the sky to a formula? It is never twice the same color. And the water! It may be blue or green or gray or purplish, but never that blue throughout. Not just cerulean blue with a little white added—a different color each time.

Beware of receipts for painting—it looks like the work of someone who studies out of doors by proxy.

Distant shore. When you have a dark horizon line, look at the dark edge of some shadow and then you will realize that there is not so great a difference between sky and water. Do everything in relation to a positive shadow in the foreground, and in trying to decide what the color of one spot is, don't look at it too long; keep your eye going over the whole.

§ § §

An old wreck on the ocean side, where students went for picnics.

It's a good scheme to go over to the ocean once in a while, but it is also a good scheme to leave your painting materials at home. Don't try to make pretty pictures—paint for fun and for practice, not for exhibition. We are going to take home ability and knowledge, not finished canvases.

§ § §

Crowd at circus.

In a group don't think of separate figures, think of spots of color. In a large crowd several people would make one spot.

Do the big salient things and the little things take care of themselves.

§ § §

Boat against wharf.

Make all your shadows hold together a little more than you have done—the boat in shadow and the shadow on ground hold together, opposed by the brilliancy of the sky and the brilliant light on the boat. Do not try to separate the light on the boat from the light of the sky so much—keep it as close together as possible.

§ § §

When you were painting that water you were looking too much at it—don't break it up to the extent of losing the whole color note. Your eye ought to have been over here on the ship.

§ § §

Boat drawn up on beach.

Make a full volume note, more vitality, more color—by mere weight of paint you could have made it sing a little more. It would have looked a hotter day if there was more vitality in the background.

The sky should be lighter—and the water. Try looking at something—a wave for instance—the dark side of it; then hold up something near you—a stick perhaps—and see how light the water really is.

§ § §

Reflections of a boat in the water. Note wave edges as a pattern. Think of sunny reflections in water as a carpet, seek the design on the surface.

Don't be so mechanical about reflections. The light on the water should come up to the edge of the boat a little stronger. Reflections in water are lower in key than the thing itself.

§ § §

Painted too much in spots, dory by itself, trees by themselves, etc.

§ § §

Low tide on the beach. In this dock I would rather have one spot of color than to be obliged to count all those piles. I don't believe there was room for so many. If you had the right note under your wharf you would never care whether it was piles or just a note of color. Real painting is like real music, the correct tones and colors next to each other; the literary and sentimental factors add nothing to its real value.

§ § §

Painted under wharf —looking out through the piles. I would rather see the general note of those piles given and less of the construction of the wharf—in your anxiety to get your piles structural you have lost your sense of the value of the color of those piles against the land.

§ § §

63

Hollyhock lane. The wrong point of view—just a little too much a landscape. For picture making it's all right, but for painting you have done almost everything you shouldn't do. Everyone wants the incident—if they want holly-hocks, they want hollyhocks. The painter goes out and tries for the color of things and their right color relation against each other. It is an impersonal beauty—not a literary beauty.

§ § §

Railroad station and two freight cars. Here is another subject taken out near the station. It is surprising how much paintable material there is over there, the last place in a town where you would ever expect it. The curse of us all is to do what the world calls beauty—not to look out with our own eyes frankly on the world.

§ § §

Don't invent little schemes whereby you can get ahead of nature, little schemes to make it look like nature. You don't need to know how to do it, all you need is to do it. The things that count and make it look like out of doors are the big differences between the shadow and the light side.

§ § §

If your eye is out of focus you will do good things. Do two or three spots of color rather than the shapes of houses. Paint the boat by not thinking of it as a boat—get the light and shade as they come together. Boats as a subject are liable to be sentimentalized, so try to be cold-blooded about them.

§ § §

It is not the sentimental viewpoint but the earnest seeking to see beauty—in the relation of one tone against another—which

expresses truth—the right attitude. If you're a thoughtful humble student of nature, you'll have something to say—you don't have to tell a story. You can't add a thing by thinking—what you are will come out.

§ § §

I want you to get something to work with—your ability to see —that's the whole job of a painter.

Your ability to see is your tools of trade; nothing else matters. Beautiful seeing is the desideratum. Remember, when you hear people say they can see a thing but not do it that they cannot really see it. If they did, they could do it even if they put the paint on with their fingers.

§ § §

A sea, a wharf, a little white cloud, a white house, green shutters, two chimneys: why? Open your eyes wide and divide the thing into fewer general spots.

§ § §

I think you looked at that white sail in the distance and thought, "There is no such thing as pure white in nature." So you modified it. It would have been more true to nature if you had painted it the way it looked—a brilliant sail.

The ring, the call, the surprise, the shock that you have out of doors—be always looking for the unexpected in nature, do not settle to a formula. Get into the habit of doing what you see, not what you know. Human reason cannot foresee the accidents of out of doors. Humble yourself before nature, it is too majestic for you to do it justice.

§ § §

White houses in the sun. Don't divide that passage up into the edge of the roof and the shadows on the house. Let the tone run right across. Your separation has been of objects not of color values—make the things into a larger pattern in your landscapes. The thing was beautiful and attracted you but the moment you began you did the fence as a carpenter and the house as an architect. Try to move the big spots around until you have some kind of drawing—don't *try* to do bad drawing but don't make an outline and fill it in.

§ § §

It may have been accidental but you knew enough to let this alone. The intelligent painter is always making use of accidents.

§ § §

White houses. What a delightful pattern that group of houses makes! Get the attitude of looking at nature as a pattern. Do not do individual houses, realize that the whole is a spot against the sky. Look at the thing as a mosaic.

Man-made things, buildings, boats, etc., we see more decidedly than the other things in a landscape.

You have made a lot of little holes in those houses—of course, I know they are windows, but windows have a way of staying on a house. Get the idea out of your head that it is a window and make it a spot of color in relation to this wall and the sky. Don't worry about them—try to make the truth and the rest will come. By that I mean, make spots because they're spots, make them for the benefit of the whole note you're painting.

Consider windows as accents to make the house look solid.

A window should be a spot of color to leaven the shadows.

§ § §

Make the house as a spot of color that cuts into the spot of green that is the tree. Get the color values first, then make it a house. You have done these houses like an architect, not like a painter.

§ § §

White house with red awning. Now this is very well—you feel you could walk around it, because the colors are true. It is no mean trick to make a note of red stay on a house as you have made that stay.

There is no paint made to make the white on a white house, we have to fool the public, make them think it is as we see it. See how dark you can make shadow and still preserve the differences.

When painting a cast shadow, work from the edge in. Take the edge of a house in shadow and paint it in reference to the other things.

§ § §

Gray day. The moment you get a shadow on a white house near the color of the sky you spoil both.

Make shadows on a white house each a little different, no two alike.

Don't mind windows over the doors but care about the shadows and spots in relation to the building. In nature the blinds made a color value which cleaned up the spot of color that was the end of the house. You have made blinds instead of spots of color. You've used no discretion in doing windows; this would look well in a hooked rug.

§ § §

White picket fence. If that fence is right the shadow is wrong —that ghastly thing could never make that shadow happen.

Don't paint to say "Ha! I see purple in the shadows"—make it look like a shadow on a white house. Paint so the spectator will say, "Oh, that's an old weather-beaten barn"—and all the time you know it's purple. In this canvas we see it's purple and only you know it's an old weather-beaten barn.

Keep off this lavender in your landscapes—I remember when this color was invented as being atmospheric. Fool the public. Yours makes me lose the sense of what the whole is and then when this color is repeated in your whites and your whites in shadow, it gives a canvas that might be seen through a slightly tinted glass. Look out for that. I want beautiful simple notes of color coming together. You would not want to go into a purple shadow like that and sit down. If the color were right it would be a pleasure to walk around there. It would be like taking a long journey with pleasant companions through a delightful country. This is like taking it with a dreadful bore.

§ § §

Very entertaining—I don't know at all what it is but I like the way it's put together. How much can be done with paint even if you haven't any sense of form at all.

§ § §

First sketch—group of students painting, in bright smocks.

This whole thing sings with the joy of being out of doors—these other things were dragged out.

§ § §

Keep this little canvas, it is a promise for the future. When I say "keep this canvas," I mean for the influence on yourself. When one does a good thing, I think it's well to keep it to show how foolish we are at other times. Keep this canvas and wonder why.

Don't mind how you splash around if you are trying to do something. Make a start intelligently, so well that I will want to see it finished. Look at nature and put a few values together.

Do not let it look as if you reasoned too much. Painting must be impulsive to be worth while—if you are a painter there is an aesthetic excitement about painting which is one of the most beautiful experiences that can be. Put things down while you feel that joy; I'd like to see you register it, and then I know some day there will be an artist born.

No one is forcing you to paint—you are doing it because you like to, so go out this week and bring in something that shows that you had a great time painting it, lots of fun. No matter how slight the effort it should be interesting.

Vitality of the first impression is surprising. Don't tame it down until you get something every one can recognize. There is a youthful boyish joy in calling attention to the fine things coming together.

Realize the value of putting down your first impression quickly.

INDOOR MODEL

Approach your subject in all humility and reverence—make yourself highly sensitive to its beauty.

If in painting a head you encounter difficulty, just disregard it as a head and treat it as you would a still life. You should go after the big spots, the relation of the figure against the background, the light spot of the figure against the shadow of the figure, first establishing highest light and darkest shadows.

You must establish a background, in the right relation to the head. Until you have the spot of the face true against the background, you have nothing to build on. Watch the big spots of color make them more subtle in relation to it. Remember that the background becomes a background only in relation to the thing you are doing in the light.

Pay attention to the big note that the head makes. Don't be afraid to paint flesh, think of it as a note of color—get the mass against the background. Close your eyes and remember back and you can visualize the beautiful note of color that was. See it on canvas before you begin—after you get that note of color you can resolve it into features. Half the likeness lies in the colors—they are the first things we recognize. Your three or four general spots coming together make the portrait, make the likeness. Everyone can supply the rest if the spot of color is fine.

The first color you put down influences you right straight through. Do not put things down approximately—you will start with a wrong note of color and unconsciously key everything to it, making all false. Paint a more positive statement; not darker,

more positive in relation. Separate the canvas into a pattern and give one color its true weight in relation to another.

Try to get your spots of color going well before you make them into a head. To make an outline first and fill in is a possible but not the logical way for a painter. The relation of two colors or two tones against each other is the fundamental of all painting. I was once painting a portrait of a man with a bald head. The color of the bald head so fascinated me, as I continually compared a spot of color there to a spot of color on the nose and elsewhere, that the portrait was finished before I was conscious of really doing it.

Keep refining the big spots. The only way to paint a head is to paint the way the colors come one against another—color spots of flesh in air. Then you can take a camel's hair brush and tickle it up as much as you like. The more you know about putting big spots of color together sympathetically the less detail is needed. We ought to conduct our work so we never do polish.

Study by doing fresh starts and stopping when you tire. If you get it into your head that you do not have to finish a thing then you will be able to stop while it is still right. And then it is right no matter how little or how much is done. Leave it there, for then your imagination will finish it for you, instead of your trying to finish it and then ruining it.

Keep your eye over the whole surface, keep your canvas interesting all over at the same time. Turn it upside down and compare it with nature—for some reason that makes you see differently.

Chase used to say: "When you're looking at your canvas and worrying about it, try to think of your canvas as the reality and the model as the painted thing."

§ § §

To a beginner. You must get the big note of light separate from the dark. After you have the spot well established go inside it and try to develop it a little more. I don't like to see a head drawn as much as that when the other things are not attended to.

Don't try to do too much with your reflected lights. You have overworked them, don't break them up so much. Don't look too much into the darks. Things should stay in a general spot.

§ § §

To an advanced student. How much that throat looks like flesh, how much this color reveals character! One sees immediately that this is flesh and this cloth. I do not care for the moustache. I had rather see the space as a spot of color—it would be much more like the man than to put something on his face that he could not possibly wear. I would rather see it as a color first and a thing afterward. It *must* be a correct color spot first; if that color spot is not right it is nothing, it is only paint. If you paint it literally with your fingers, if you get it right in relation to the face, it is a moustache. The moment you get this thing right, almost without trying the face becomes a living thing, and that is the time to make it into the thing you want. Look at the model between your fingers—it is impossible for you to mistake what you see that way for anything other than the substances they are made of. Everything in nature is true—you must have truth in your work.

§ § §

Let the light play over the flesh. Try painting across the form. Watch carefully the relation of spots, comparing one section

with another across the figure. You begin to go around the form too much—think of it as a silhouette. You are trying to make your form and coloring it, instead of letting your color make form. Try to get the note of *this* color in relation to *that*, and not the form of it. I don't care how casual you are as to form so long as the spots of color are right—go back to still life for a while to get that point of view. Remember wrinkles alone do not make form. The minute you get the relation correct between light and dark, you get form much better than highlights and dark and rounded edges.

§ § §

Nude. Volume of paint is of great help in realizing volume of form. Think of the various forms of the figure as still life.

§ § §

Don't get obsessed with the idea you are doing a head. Start the background as well as the head. A good idea is to put up a figure and concentrate on the background instead of the figure.

§ § §

Man posing—faded blue background. Watch the spot of the background and make it truer all the way around your head —it was a more beautiful thing than you have made it. I don't care what it was, it should stay behind.

§ § §

To one who painted background in after model stopped posing. Do not neglect the background, it is a vital part of the picture. Yours lacks the note of sincerity that comes when one does a thing from nature but is always missing when you make it up.

Clean up your backgrounds, they will be better.

Warm vital background for a dark head.

Don't take a piece of drapery and worry every color you have into it. Don't do wrinkles in drapery more than is necessary.

§ § §

Old fisherman. Do not try to get forms by the wrinkles of clothes. Get your colors true and you will be surprised how little else you will need. Try always for the expression of the mass of color as it comes next the rest.

§ § §

Little girl with long hair. Feel the skull under the hair. Study carefully where the hair meets the flesh. The head falls into shadow very beautifully.

In doing hair, do not overdo the spray of the hair; look at the mass with the mass of the face, see how simple it becomes. This hair is too mixed up. The big note told as a note, you did not see it so broken—look at it as a mass and see it in its relation to the face. Look out for being so lavish in your accents—it makes your canvas spotty and dry.

The trouble with your using your brush to paint hair is that we all know what it is even if you do it badly, from having seen it painted so often; but if you do it with a knife, you have to do it solely by color.

Don't be afraid of curls!—they are not curls, they are spots of color. Look up with your mind a blank and do what you

see. Don't put down a note that you know ought to be in a certain place, see it first. This of yours is very capable, as if you knew how to do it very well—hardly had to look at the model. Beware of any one who tells you exactly how to do it.

Memory work is usually done by artists who have painted all their lives—don't patronize nature, we should be very humble. It's a sad commentary on human nature that there is nothing so surprising as truth. It's sincerity that counts. Good drawing does not stop you in an exhibition, it is something else that stops you, a bit of true seeing.

Get after some heads and paint them as hunks of flesh instead of as pretty girls—after all, pretty girls are made out of hunks of flesh.

§ § §

Stop for awhile with your heads and try to get something more worthy of finishing. Practice getting *that* spot of the flesh and *that* spot of the hair so they will be more vital. Let the other things go hang for awhile. After years you will come back and have more of a foundation to make them.

§ § §

Don't drop the head on the same sized canvas every time—try to vary your work. The effect of all these is bad, the same sized canvas with the same sized head in the same spot. Get up not knowing what you will do that day and let the impulse seize you to do a large, perhaps a small one. Queer the canvas, give me a shock—forget every portrait you've ever done.

§ § §

Don't pay any attention to the light on the edge of the material unless it plays a very important part. If there is a line of light which plays a color part in the composition, put it in of course.

§ § §

What is it to the world at large what kind of a Dutch cut she wore? It's all very well for *her* to train that curl up there but see that *you* treat it as a spot of color.

§ § §

Costume model. I feel that you have done *things* too much. These objects are too well drawn. I want you to think of the juiciness of color—not that the drawing is not important, but you have lost the big spot. Give me all the beauty of tone you can but I want you to get after the other thing. Your way of working leads nowhere—the other way leads you on without limit to greater things. Be sensitive to the way things come together.

§ § §

Painting is just like making an after-dinner speech. If you want to be remembered, say one thing and stop.

§ § §

You can't start too early in studying the eye, how the lines darken and get lighter, the variety. When you are a master of fifty or sixty you will know what to leave out.

See with how few lines or spots you can paint it. You will find that the shadow under the eye is not as black as you make it—the light does not stop at the fold of the upper lid but stops

at the pupil. Focus on some point in the eye, not all over it and be sure not to get the whites too light.

§ § §

Old fisherman. Notice the oyster-like quality of the eye. That old eye probably looked like one— all swimming in moisture. Look at each eye you do with the attitude of perpetual surprise. It's not like any other.

§ § §

Draw eyebrows as one line at first. This eyebrow is too dark— it's so black it makes a hole you could drop a nickel in.

Make lips stay on the face, noting just the change of color.

Put the spot there because it's the right color and not because it draws a nose. Keep on doing portraits in the same process. Sometime when you have more time at school next winter or in your own studio, take a head in the same condition and by the same process see how much you can do with an eye socket. We have to learn to negotiate the end of a nose. Work until you can paint an ear so it doesn't look like an oyster. Not wrinkles drawn, but the color spots that wrinkles make.

Work harder on the spot of color of the face and don't think of it as just a background to make eyes on.

Now that you can paint a head that well, push it further, try to eliminate. How little it takes to make a masterpiece, how little to make a thing worth while.

§ § §

Don't make dabs of white powder for highlights, be careful to give them their local color; nothing gives so much character to flesh. The highlight should be complementary to the color of the surface it falls upon. There is no surface on your heads because the highlights are just flesh color and white, not the actual colors they are. The highlights are too high, which makes the rest of the cheek lack surface. In your canvas it is too much as if there were an artificial light on the head. Don't have one on the forehead and another on the tip of the nose—it's too scattered; join them with a line.

§ § §

Be careful of the darks on the light side of the face. They are not holes punched in, they are on the surface. Always remember that a dark color happening in a large plane of light isn't as dark as it seems. Look at the positive shadow and don't let the other darks look like slots in the face.

§ § §

Small boy in dark blue shirt—gray background. Note the different quality of the edges—try to analyze the variety of an edge. Take the figure of the little boy. That edge of the shoulder is too sharply cut. It went around easily on the shoulder and on this fold while on the contrary this other shadow was sharp. These differences give a sense of the illusion and make the object go around. Don't try to get your form by stroking—the edge of the shadow draws form. Your painting is what one calls edgy for want of a better term—the reason is that you haven't observed the character of your shadows. Don't be afraid of edges—the more you know the more subtle, of course, will be your seeing. In youth we are obvious.

79

Watch the edge of that shadow down the edge of the nose a little more sharply. See where the shadow goes hard and where it loses itself. There are some places where the shadow should be a little lighter and the light on the nose a little lower—the result would be that it would be more like flesh and less like a plaster cast.

§ § §

The exact difference between the note of the head and the note of the cloth would have made that more like cloth. You lose sight of the big things by your attention too much to the little things; I prefer exaggeration to such carefulness. Have the ability to see largely.

§ § §

The shapes in round objects are quite angular at times. Should you feel them that way, well, make them that way on your canvas.

§ § §

I expect you had this better at one time and then finished it —and one always *does* finish it when one finishes up. Keep it in a state of being unfinished and try to put off the evil day of finishing as long as you can. Keep looking at the beauty of the big spots and thinking of their relations to each other and the first thing you know it will be finished.

§ § §

Nude with blue background. Here you missed the big note, the whole impression, the big simple music that the old masters saw when they painted a figure. You are too careful—but, of course, you can never be too careful. I expect you were careful about the wrong thing.

§ § §

Don't copy the model—eliminate and see with how little you can paint it; that's why you are trying to be an artist. Keep your eye over a little bit bigger surfaces. Get away from the idea that it must be a picture—do a little well. If a thing is right, it is right no matter if only a little is shown. I'd rather see one glimmer of flesh than the careful drawing of those arms. Make it less like a face, more like a piece of flesh, more of a vital living note. I want to feel that these people you paint would bleed if you pricked them, would kick back if you kicked them.

§ § §

Half close your eyes and silently observe where the lines come to the surface and disappear. Your portrait has no continuity of line, it looks too much like a scheme.

§ § §

This canvas of yours looks just a little black and white, it looks like a reproduction of a painting. Make your work as colored as you dare and then make it a little more so!

§ § §

Dark painting looks better varnished. One in high intensity often is better not varnished.

§ § §

Child. Ribbons on head should be accents in picture, not ribbons. You may find that one small detail is the keynote of a whole canvas.

§ § §

You have tried to carry that farther than you knew how. If you don't do what you don't know, you don't give yourself

away. If what you have done is right, people will think you have all the power in the world—believe me, you will get on faster by stopping on the right side. If you conduct your work in that way by carrying it each time as far as you know, each time you will go a little farther.

Consider the great singers, musicians. They always make you conscious of a reserve of power, something greater that they are capable of. Never fire your last shot. Power is real strength—don't give all, have reserve.

Never mind if your whole canvas isn't successful. If one spot is successful it is enough. Do a bit of truth. When you meet a spot of real truth in a painting you forgive—oh! so much. We walk past miles of canvases, being able to find no technical fault with any, until suddenly we are halted by one, perhaps ugly in its choice of subject, but which is immortalized by its expression of truth.

Have the humble attitude. To see things simply is the hardest thing in the world. When a man is sixty or seventy, he may be able to do a thing simply and the whole world rejoices. You can't begin too early, for this is not a thing of a month or a day. The value of a canvas depends almost entirely on your mental attitude, not on your moral attitude; depends on what kind of a man you are, the way you observe. Study continuously, developing yourself into a better person, more sensitive to things in nature. Spend years in getting ready.

Paint starts for twenty years and some day people will be digging them out of dust heaps and selling them for ten or twenty thousand dollars because they have something to say. A sketch has charm because of its truth—not because it is unfinished.

WATER COLOR

A good water color is a happy accident—if you qualify the statement by saying that the greater the artist, the oftener the accident happens.

I advise you to work in oil even if you want to become a water color artist. Water color is a messy, runny medium and is hard to study in—you have to take care of edges and can't see tones because the colors dry lighter. Keep right on if you wish but do not pay too much attention to their being water colors—just make them paintings. Do them as you do oils, that is, try to get contrasts. Don't be afraid of the medium—put down what you see as spots of color rather than as form.

Don't make them too precious—don't bother about the object but make the spots of color against each other in relation. Color makes the form—Manet did it with spots of color, spots of color together telling as one.

Use cheap colors, if you will, but buy good paper—fifty per cent and more of your water colors depends on the paper you use. Work very wet and don't be afraid of the colors running into each other. Use more color, play with it, yell at me with color. Give me something dripping with sunlight—make some horrible free studies.

Remember to put on a deeper note in water color. Use more color and as it dries blob on still more color if it fades out.

Let a water color get away from you. If you can't get it back, try another.

I am always telling you to be looking for subjects. Have along

with you always a little canvas or a small piece of paper or a tablet—if you like, look through a space cut in a card for your composition. And especially with water colors it is advisable to put colors against each other in small compass. In that way it is very much easier to put one color against another and get their relation.

Don't have any particular system about water colors, no special hours to do them in. Go at it just when you feel like it. Give me a little more fun and the only way to do that is to have a little more fun yourself. See what you can do with your daring with color and your ignorance mixed with it.

Never try to repeat a success.

Make small water colors so that windows and things are just spots of color—make spots produce the objects. Hold up your finger to eliminate the outline and look for the comparison of color. Try to paint across the form so that the only way to get form is through color.

Get something strong enough in the foreground to make the background simple: a person, a fence, or a boat.

Consider your problem as a silhouette, a dark form against a light field or a light form against a dark background. The Sargent water colors are a liberal education in the study of edges.

I don't think flowers are good to start in with—take something more rugged like a building outdoors. Such things are more easily seen than the subtlety of a flower.

Paint a tree—look at the sky in comparison—see the tree in relation to the sky, the house, the road.

Think of color first and house after, not house first and color after.

§ § §

White house, casting shadow on lawn. Don't let your water colors look pale and conventional as though you had dropped into a manner of doing a set thing. Get more vitality in them. In your study let the shadows take hold of the grass a little more.

§ § §

Make your water colors larger and richer in color. Get acquainted with your palette, dip into pans that you almost know won't do. Experiment.

§ § §

Bright colored wash on a line drying in the sun. These are a little like colored drawings—it looks as if you were afraid of losing something. Your clothes line does not sing the way it ought to. You have been obsessed by the fact that they are water colors not by the planes and spots. That study was done because they were houses to you and not because they were dancing notes of color in the joy of sunshine. Just get more into a loose way of working and slop around and have some fun—the fact remains that when you are going after the big things the work is apt to be a little sloppy.

§ § §

Irritatingly correct—charmingly incorrect.

§ § §

White house with lawn. Almost the white paper with a bit of yellow over it would make sunshine on the grass. Keep those shadows simpler and darker against the sky—you haven't dared to make your darks and haven't quite dared to make your lights.

§ § §

Sargent water colors, so beautiful—architecture in shadow.

§ § §

Where you have a roof near you, break it up in color.

§ § §

A boat beside a wharf sings with the joy of color—get the bang, the sparkle of nature.

§ § §

To student showing both oil and water color studies. Your water colors are less mannered than your oils. It is owing to the difficulty you had with your medium and your insistence on success, your willingness to do anything to make them look like the things you were painting. What you need is to have as hard a time with your oils as with your water colors; here you arrive at the result too soon and are too easily satisfied. You should have more sincerity, you were not keen enough for the exact difference between the houses and the trees and the sky.

§ § §

Each day has its own individuality of color.

§ § §

View down the road. Don't make pictures instead of spots of color. These are too much like water colors and not enough like nature—do not be guided by the conventions of water color.

In water colors get the big note and never mind if they are sloppy. Get out and slop around and have more fun—see if they can't look as if you were somewhere near the place when the crime was committed! I don't want them sloppy but it is impossible to get both the neatness and the light—if you could do that you would not be here—you would be the best master alive.

CONCLUSION

Remember that all painting is seeing, not doing. A painter spends his life in despair trying to paint the beauty he sees—in so doing he approaches more beauty. Knowledge will come to you unknowingly. Think of what beauty is revealed to you; try to put that down.

Art is a necessity, beauty we must have in the world. Painting and sculpture and music and literature are all of the same piece as civilization, which is the art of making it possible for human beings to live together. When I speak of art I mean painting, architecture, music, the art of literature, sculpture, the theatre, in fact everything that's creative—anything that makes a thought, an idea, or a thing grow where nothing grew before; or a fundamental truth expand and show some new angle of beauty which calls special attention to its being a fundamental truth. All these things and many more come under the category of beauty which is a better name for art than the word itself.

The most important thing is to have something to say—it's so simple as to be almost idiotic. Look at nature as a silhouette and tell how beautiful it is. You cannot begin too early to practice this, for a painter's job is to see a tone more beautifully than others do. If a man lives a lifetime and seriously and humbly studies these things about nature—the beauty of the spots of color made by objects as they come together—it cannot but react on him as a man and, by the time he has painted for forty years or so, he'll begin to have a glimmer of what beauty is. If he has sufficient humility he may become eligible to help other people.

He becomes a man who does not see as others see. That's why I insist that all of you get right down to rock bottom.

When you start to paint you are a very crass, crude, unseeing being. Humbly, prayerfully almost, make the spots of color as they are and trust in the outcome.

Take care of your honesty—search and the rest will be added unto you. Avoid the magazine cover effect—don't paint pretty pictures, get the dirt and grime of every-day existence. Be humble like a child; don't feel like a professional artist. Be careful about things looking nice to you and giving you the sensation of your being a good painter. To most people there is nothing very beautiful or inspiring in a side of beef in a butcher's shop, but Rembrandt saw the beauty and painted a masterpiece. There is more religion, more humanity, more of something that makes life worth living in an ounce of Rembrandt's beef than in a mile of Guido Reni's angels.

Go right ahead and try to see more interestingly, more vitally that means, and so more truly. It is virility of color that makes truth. The most poetic thing ever painted was done by a man striving for the truth: trying to be a craftsman instead of a poet. A great painter is always a student, always seeing more until he has to send the canvas for exhibition.

If, when you are painting next winter, you get to a point in a canvas where you don't know what to do, just go back and simplify the big notes of color. Realize that the notes of color make the object you're doing—reproducing the relation between color values recreates the thing, draws the object for you.

However, you'll have to draw one of these days. No matter how much ability one is born with, training of the eye is necessary. Drawing you will struggle to do until you are ninety. We first learn academic drawing; how to put a nose in the middle